⌈FRAMEABLES⌋

◆

*21 prints
for a picture-perfect home*

Cloudscapes

Flammarion

Head in the Clouds

To trace the evolution of the cloud through centuries of art history is to encounter pictorial upheavals and liberating artistic visions. Clouds are laden with symbolism. In classical art, they float across the skies and heavens as stylized, simplified motifs. Later, they appear in representations of sacred subjects in mythological and religious paintings. Ultimately, clouds became an artistic subject in their own right, as landscape began to be recognized as a worthy pictorial genre.

The modern classification of clouds is based on Luke Howard's 1803 "Essay on the Modification of Clouds," which listed clouds under the structures they displayed, such as cumulus (heap) and stratus (layer). John Constable and Eugène Boudin were both intrigued by these discoveries and annotated their drawings with scientific observations. Clouds became a principal subject in their work, thereby creating a new thematic category in art. An inescapable presence in the skies, clouds can heighten feelings and be a liberating influence for painters. Cloud studies redefined the concept of sketching and preparatory drawings for many artists, including Edgar Degas, Eugène Delacroix, and Ivan Shishkin. In 1841, paint became available packaged in flexible tubes, and this innovation simplified life immeasurably, enabling artists to experiment with plein air painting techniques. The airy iconography of cloudscapes became a favored subject for the impressionists. The works of Claude Monet and George Hendrik Breitner reflect the artists' attempts to paint the effects of a cloudy sky filtering the sun's rays. The ephemeral nature of clouds encouraged introspection and creativity, continuing to challenge artists throughout the twentieth century. Clouds are omnipresent in the work of René Magritte: mysterious and unearthly, they capture the viewer's imagination. As the century progressed, pictorial experimentation tended toward abstraction and greater subjectivity. Mark Rothko's clouds lack identifiable forms, but emerge transcendent in an interplay of light and color. The skies of the trailblazing artist Georgia O'Keeffe are seas of minimalist clouds. A fleeting presence, destined to dissolve into the heavens, the cloud is poetic and changeable by nature—a subtle metaphor for artistic genius.

<div align="right">

P. B.

</div>

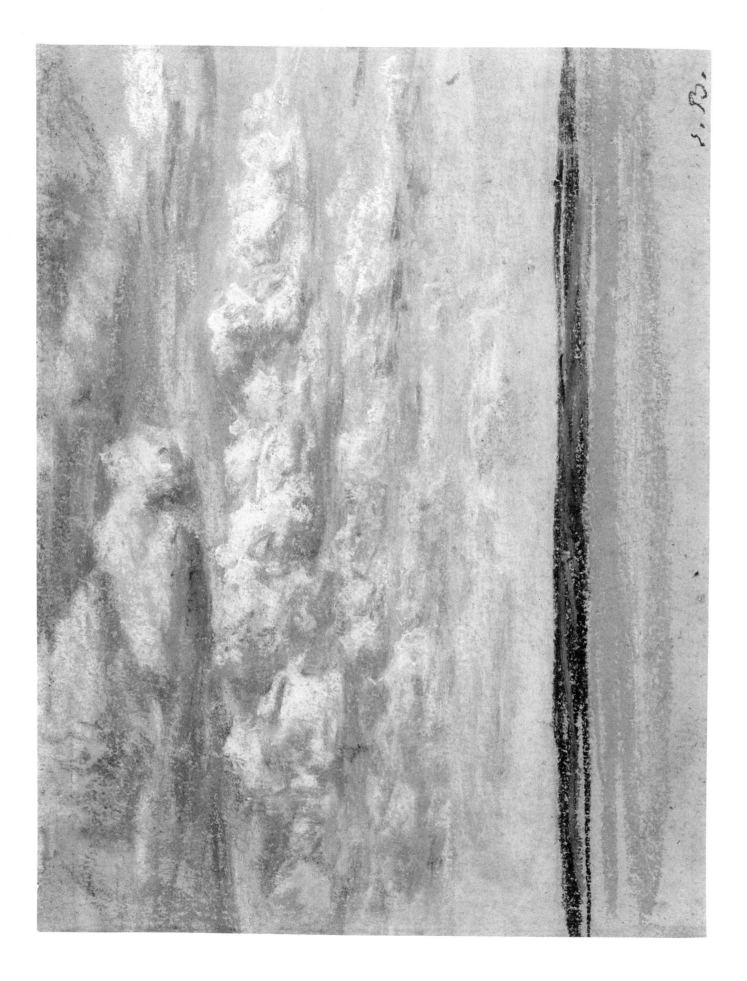

1854–59

Eugène Boudin

White Clouds, Blue Sky

Pastel on paper
5¾ × 8¼ in.
(14.8 × 21 cm)
Musée d'Art Moderne
André Malraux, Le Havre

Where to See His Works

Brooklyn Museum, New York
Musée des Beaux-Arts, Dijon
Musée du Louvre, Paris
Musée Eugène Boudin, Honfleur
National Gallery of Art, Washington, D.C.
Yale University Art Gallery, New Haven

The Work

Long blue streaks of pastel suffice to represent the seashore. Despite its superb economy of expression, the lower part of the drawing is not the main subject of the composition. These subtle shades of blue appear again—nuanced and carefully worked—in the sky above. "Bathe amidst the heavens. Convey the subtleties of clouds. Suspend their masses in the background, far from the earthly gray haze, letting the azure sky burst through. I feel all of that, at the dawn of my vision." This was Eugène Boudin's goal. He sought to capture variations of light in order to convey atmospheric effects. The artist's sketchbooks and correspondence are filled with his impressions of coastal views; he observed and drew passing clouds for hours on end. Howard's 1803 study of the structures of clouds intrigued artists, including Boudin, who was fascinated by the topic and noted various technical data and fragments of poetry on the back of his works. Using oil, watercolor, and pastel, the artist executed hundreds of sky studies. Boudin began to blur the distinction between sky and water in the 1880s, when "the king of the skies" (as Jean-Baptiste-Camille Corot called him) began to create mirror images of clouds reflected in the sea.

His Life (1824–1898)

Eugène Boudin, a native of Honfleur, was the son of a sailor. After an unsatisfactory experience with seafaring and an early job with a printer, Boudin launched a paper supply and framing business in 1844. This occupation gave him access to a multitude of artistic contacts, and he began to practice drawing with the encouragement of Jean-François Millet and Thomas Couture. In 1846, he decided to become an artist full time, and he moved to Paris. After traveling extensively, Boudin began to focus on seascapes. He painted numerous works around Le Havre in the company of Monet, and he had a decisive influence on this young artist who would become an impressionist master. Boudin participated in the first impressionist exhibition in 1874, but he did not become further involved in the movement. A dedicated painter of seascapes and a pioneer of plein air painting, he devoted himself to depicting the fleeting atmospheric effects of the shoreline and the sea.

*The painter
of clouds*

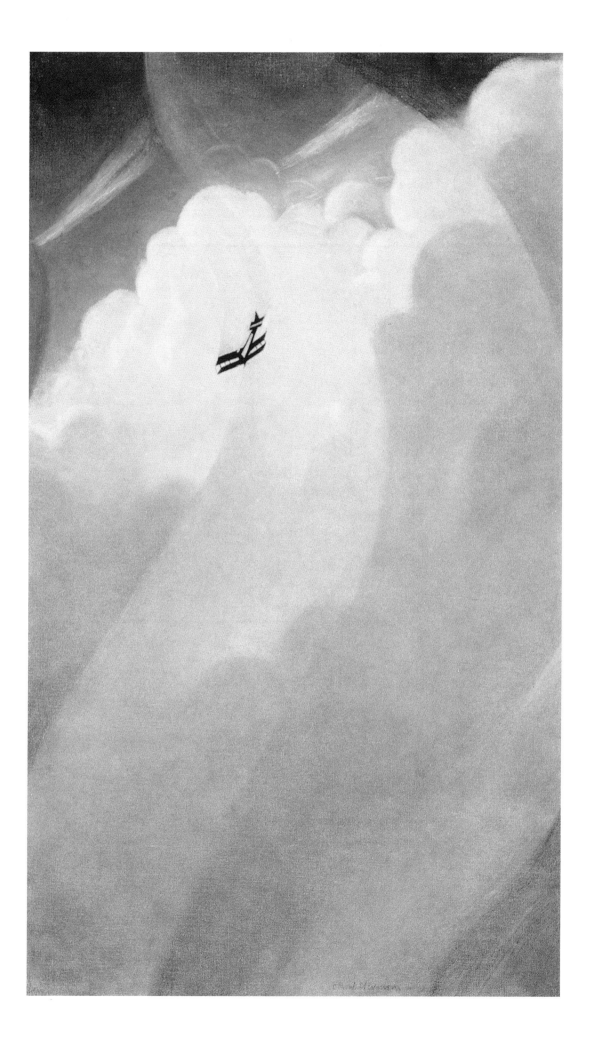

1917

Christopher Richard Wynne Nevinson

Spiral Descent
Pastel on paper
29 ½ × 17 ¾ in.
(75 × 45 cm)
Private collection

Where to See His Works

Canadian War Museum, Ottawa
Imperial War Museum, London
Museum of Modern Art, New York
Tate Britain, London

The Work

Plummeting downward, an airplane whirls through a cream-colored sky. The vertical composition pulls us into the vortex of the plane's controlled dive, emphasized by the vertiginous mass of cumulus clouds. Like minuscule punctuation marks in the immensity of the heavens, rays of sunlight illuminate the plane's passage. Nevinson expressed the dehumanization and violence of war in many of his canvases and lithographs. This work is less harsh and differs from other compositions in which Nevinson deployed explosive forms and bold colors, echoing the work of the futurists. He believed an abrasive style was best suited to expressing the brutality, violence, and ugliness of the emotions produced when confronted with the hideous reality of the European battlefields. Nevinson is considered one of the early exponents of aeronautic-themed artworks. He did his preparatory sketches from the air, positioned in observation balloons and planes.

His Life (1889–1946)

Christopher Richard Wynne Nevinson was a London-born painter, engraver, and lithographer. He studied at the St John's Wood Art School and the Slade School of Fine Art and enrolled at the Académie Julian in 1912. He had close friends in avant-garde artistic circles, particularly Filippo Tommaso Marinetti, the leading exponent of the futurist movement, akin to British vorticism. Nevinson consolidated his reputation as a painter in the volume *Vital English Art*, published in 1914, in which he stated that he felt a profound aversion to the refined artistic techniques of his predecessors. During the war, he served for several months as an ambulance driver on the French front. In 1917, he was named an official war artist. He witnessed multiple atrocities as the war and its diabolical machinery became the subject of his canvases. After the armistice, Nevinson turned to painting landscapes and cityscapes, but he was once again commissioned as an official war painter in the 1940s.

An eminent artist of World War I

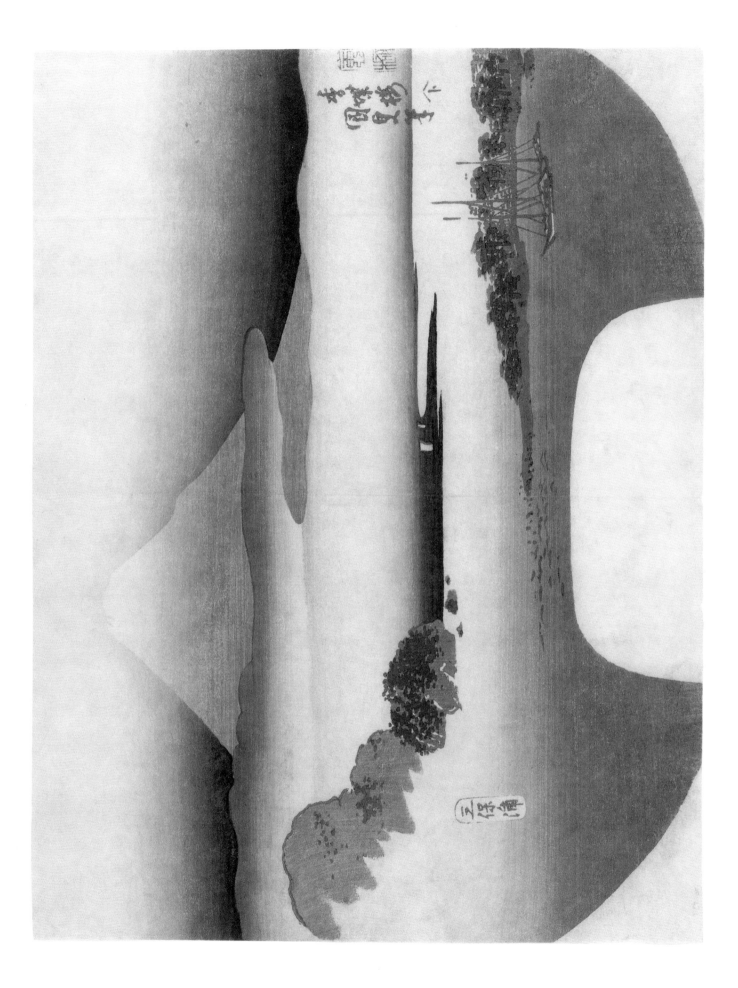

1830

Utagawa Kunisada (Toyokuni III)

View of Fuji from Miho Bay
Colored print on paper
8 ¾ × 11 ½ in.
(22.4 × 29.1 cm)
Private collection

Where to See His Works

Los Angeles County Museum
of Art, Los Angeles
Minneapolis Institute of Art, Minneapolis
Musée des Beaux-Arts, Rennes
Musée Gustave Moreau, Paris
Musée National des Arts
Asiatiques—Guimet, Paris
Museum of Fine Arts, Boston

The Work

Looming through the clouds, Mount Fuji dominates the landscape. It is instantly recognizable, soaring in the background over Miho Bay. The mountain seems suspended between earth and water, floating above the seascape—a numinous presence. The form of this composition suggests a fan. Its printing technique, known as *uchiwa-e*, was very popular in the Edo period. The work's monochromatic effect is achieved by a printing method that employed Prussian blue, a technique called *aizuri-e*. The artist controlled the colors by applying the ink in shaded layers on the wooden printing block. Varying light effects were obtained by superimposing the printed impressions. Toyokuni III made a number of landscapes in the 1830s, but he never fully developed his work in this genre, despite his promising debut.

His Life (1786–1865)

Utagawa Kunisada (Toyokuni III) was born in Edo (today's Tokyo). He demonstrated creative talent as a young child, and at the age of fourteen was admitted to the Utagawa School, the foremost center for *ukiyo-e* ("pictures of the floating world"). He trained with Utagawa Toyokuni I, one of the great masters of wood engraving, whose name he assumed several years later. His works depict traditional subjects including *kabuki*, *bijin* (female portraits), *shunga* (erotic engravings), and prints of historic subjects. He collaborated with Hiroshige and Kuniyoshi, producing prints between 1840 and 1850. Toyokuni III created over twenty thousand works in the course of his lifetime.

An undisputed master of woodblock printing

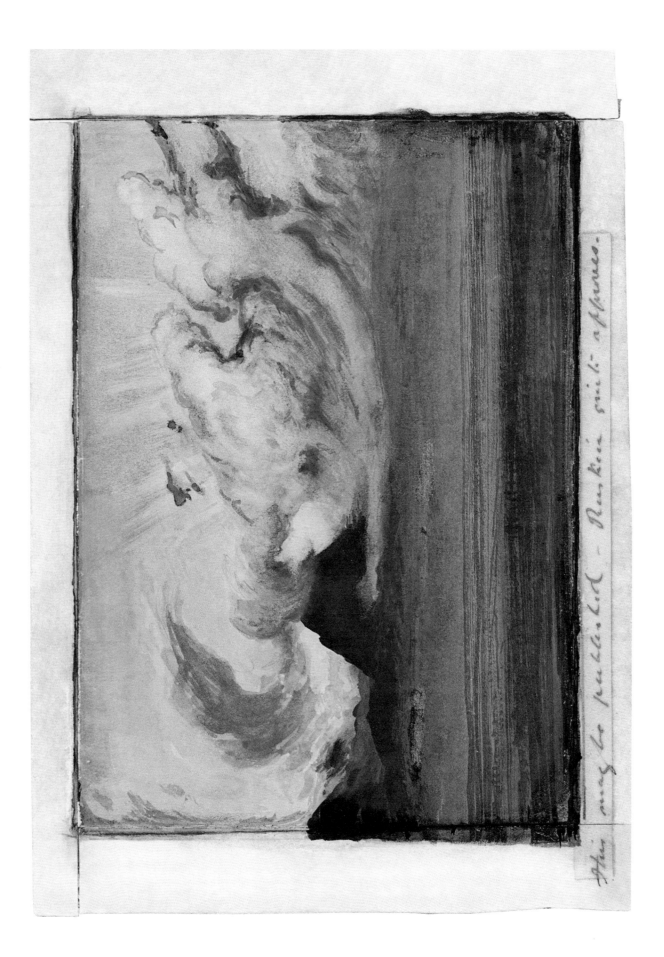

1858

John Ruskin

*July Thundercloud
in the Val d'Aosta*
Watercolor
5 × 6¾ in.
(12.6 × 17.4 cm)
Ruskin Library, University
of Lancaster, Lancaster

Where to See His Works

British Museum, London
Morgan Library and Museum, New York
Tate Britain, London
Whitworth Art Gallery, Manchester
Yale Center for British Art, New Haven

The Work

Clouds traverse a stormy sky: their motion suggests dancing waves. Far more tranquil, the water itself is a calmer presence in the lower part of the composition. In the distance, a mountain is gradually engulfed by cumulus clouds, which part to reveal luminous sunbeams beyond. In *Modern Painters* (1843), John Ruskin saw contemporary painting as "in the service of clouds," and he believed this interest in "cloudiness" was a distinctive feature of modern painting. Depictions of the sky and a fascination with clouds were manifestations of the search for nature's very essence, always in continual flux. In his quest for truth, the modern artist pursued a path that diverged from the practices of traditional landscape painters. The artist's objective was no longer to represent the beau ideal, the height of loveliness. The goal now was to convey nature's particularities and capture its fleeting phenomena. In 1848, Ruskin hypothesized that his era's fascination with clouds was attributable to climatic changes that created new types of clouds in early nineteenth-century Europe.

His Life (1819–1900)

John Ruskin was a London-born critic, artist, writer, painter, and sociologist. He studied painting at Oxford University and soon became an influential figure of the Victorian era, publishing his most significant works on art between 1840 and 1860. His theories were based upon the concept of truth: the goal of art is to observe and depict what actually is. Realism could not be reduced to mere material resemblance—the creation of art required the full personal engagement of the artist. Ruskin was a proponent of the Pre-Raphaelite Brotherhood, and advocated a return to the purity of primitive Italian painting. He admired Turner, considering him the greatest painter of his age. Ruskin's writings were a major source of inspiration for the Arts and Crafts movement. His theories were controversial, and he disseminated his ideas through his teaching.

*Debating the relationship
between painting and reality*

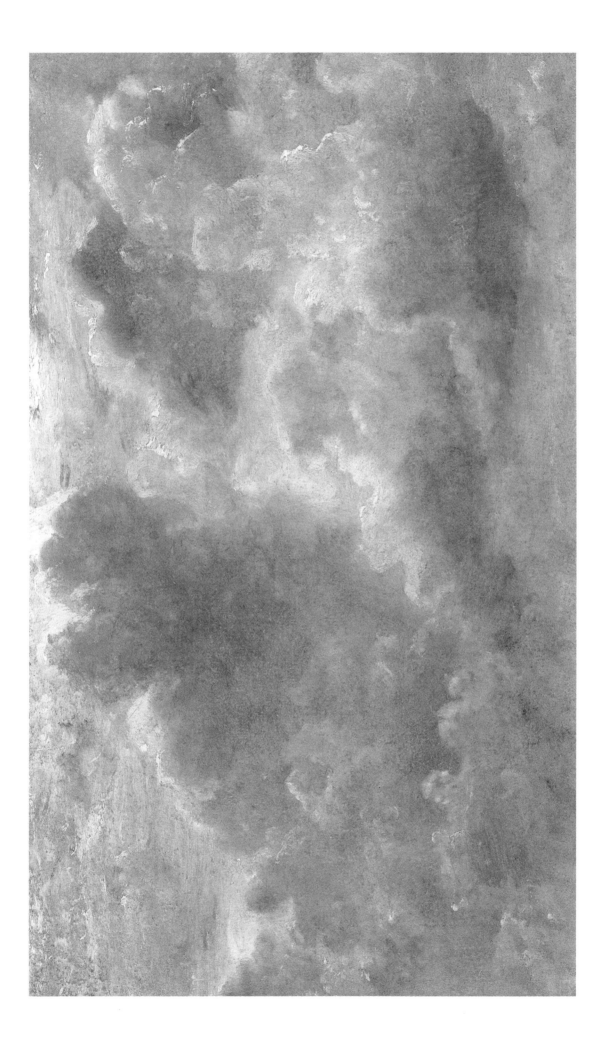

1822

The Work

"I am determined to conquer all difficulties and [painting the sky] is among the most arduous." Painted directly from nature, these clouds are in tumultuous, almost thunderous, motion. Constable was fascinated by meteorological events and began studying these phenomena very early in his career. The artist devoted himself to making cloud studies in the village of Hampstead between 1821 and 1822, and he noted the weather conditions and the strength and direction of wind gusts on the back of these compositions. Each type of cloud had to be identifiable. Working in an era when landscape painting was considered to serve a purely decorative function, and history painting was regarded as a nobler genre, John Constable cultivated landscape as a worthy subject in its own right. His novel approach made him a precursor of impressionism.

His Life (1776–1837)

John Constable was an English painter born in East Bergholt, Suffolk. He attended London's Royal Academy in 1799, where he studied landscape painting. Influenced by seventeenth-century landscape artists, including Claude Lorrain and Jacob van Ruisdael, Constable made this genre his preferred subject. A close observer of nature, Constable worked outdoors and was one of the pioneers of plein air painting. He was not elected to the Royal Academy until 1829, but he experienced great success and recognition in France. His oil sketches and watercolors are lyrically expressive. Numerous painters, including Eugène Delacroix and Théodore Géricault, were later influenced by his use of juxtaposed brushstrokes to convey subtle variations in light and atmosphere.

John Constable
Cloud Study
Oil on paper,
mounted on canvas
12 × 20 in.
(30.5 × 50.8 cm)
Paul Mellon Collection,
Yale Center for British Art,
New Haven

Where to See His Works

The Metropolitan Museum of Art, New York
Musée Bonnat-Helleu, Bayonne
Musée de Tessé, Le Mans
Musée du Louvre, Paris
The National Gallery, London
National Gallery of Art, Washington, D.C.
Tate Britain, London
Victoria and Albert Museum, London

A new understanding
of landscape painting

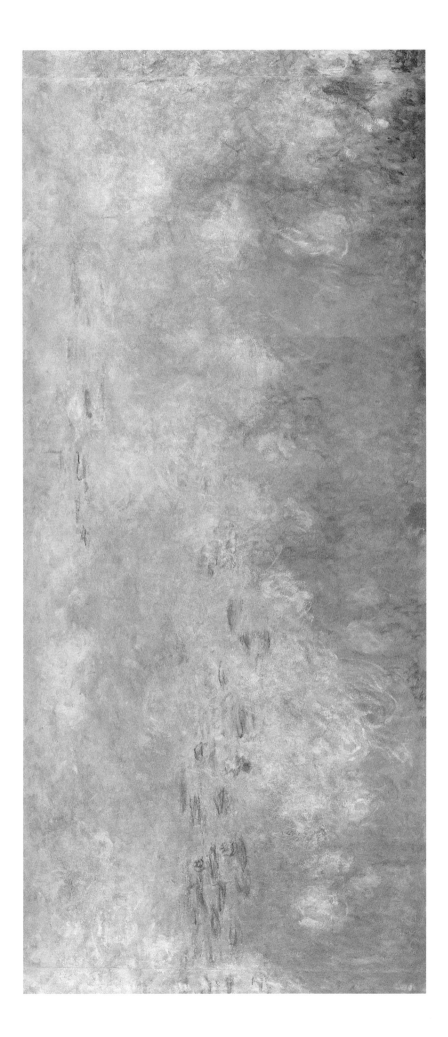

1915–26

Claude Monet

Water Lilies: The Clouds
(detail)
Oil on canvas
6 ft. 6¾ in. × 41 ft. 10 in.
(2 × 12.75 m)
Musée de l'Orangerie, Paris

Where to See His Works

Art Institute of Chicago, Chicago
Guggenheim Museum, New York
The Metropolitan Museum of Art, New York
Musée d'Art Moderne et
Contemporain, Saint-Étienne
Musée d'Orsay, Paris
Musée des Beaux-Arts, Caen
Musée des Beaux-Arts, Rouen
Museum of Modern Art, New York
The National Gallery, London
National Gallery of Art, Washington, D.C.
Palais des Beaux-Arts, Lille
Philadelphia Museum of Art, Philadelphia
Walters Art Museum, Baltimore

The Work

The viewer's gaze struggles to discern the individual elements of this composition. Does it depict water seen from above, or the reflection of the sky seen in the water? We soon realize that the subject matter is really a pretext for painting light and its infinite variations. To evoke this watery vision, the artist pours out colors from his palette, like a spontaneous, ephemeral impression. There are no outlines; the individual elements dissolve, supplanted by the profound, abstract emotions experienced by the artist. In 1914, Prime Minister Georges Clemenceau commissioned Monet to paint an imposing series of eight works to be hung in a specially designed rotunda. It was a unique format for depicting a landscape changing with the passage of the seasons. In this mature work, the artist's brushstrokes encourage the viewer's gaze to wander across the composition. The paintings were officially inaugurated on May 17, 1927, in the Musée de l'Orangerie, a year after the painter's death.

His Life (1840–1926)

Painter Claude Monet was born in Paris and grew up by the sea in Le Havre. In 1859, encouraged by Eugène Boudin, he applied to the École des Beaux-Arts in Paris, but was admitted to the Académie Suisse instead. Following his military service, he met his future acolytes Pierre-Auguste Renoir, Frédéric Bazille, and Alfred Sisley, like-minded artists who shared his vision of painting. He emphasized the mastery of variations in light in landscape painting and offered a new approach to the use of color. Monet exhibited for the first time in the 1865 Salon de Paris, before the impressionists organized their own exhibition in 1874. He settled in Giverny at the age of forty-three. Monet painted canvases in series, studying the effects of light on a variety of subjects, including his *Poplars* and *Haystacks* (1891) and *Rouen Cathedral* (1892–94). By the end of Monet's life, the artistic vanguard was turning toward new challenges, but he remained a free spirit who continued to work on an imposingly large scale.

*The fleeting impression
of a moment in nature*

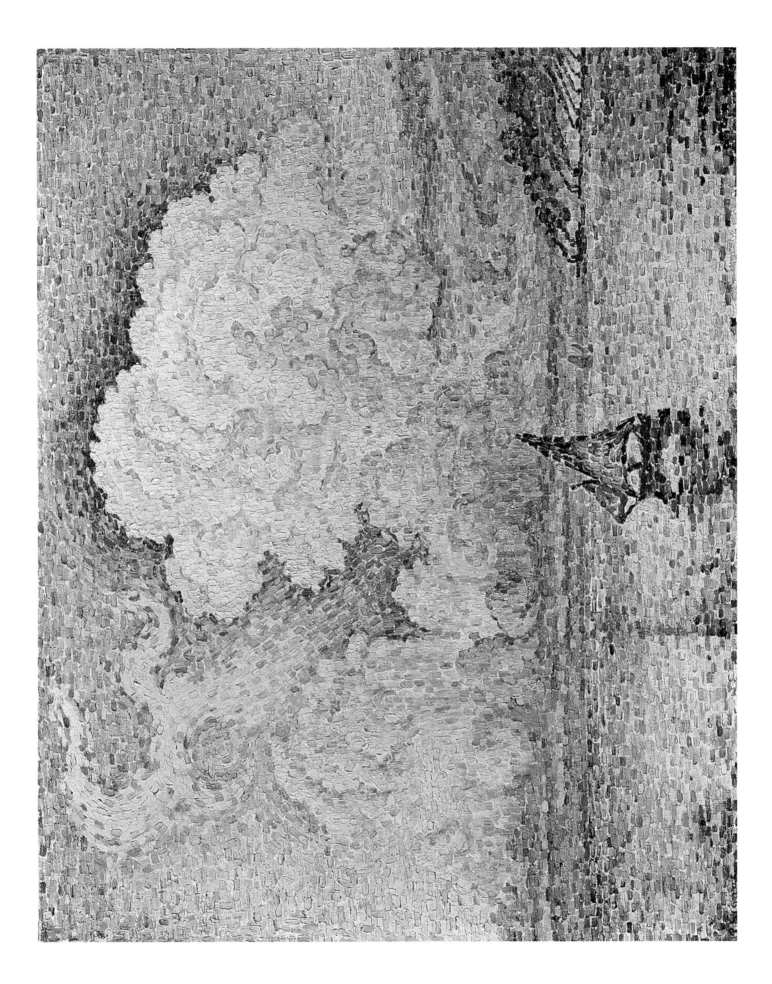

1916

Paul Signac

Antibes, the Pink Cloud
Oil on canvas
2 ft. 4 ¾ in. × 3 ft. ¾ in.
(73 × 92 cm)
Private collection

© Bridgeman Images

Where to See His Works

Dallas Museum of Art, Dallas
Fondation Bemberg, Toulouse
Minneapolis Museum of Art, Minneapolis
Musée des Beaux-Arts, Chambéry
Musée des Beaux-Arts, Nancy
Museum of Modern Art, New York

The Work

Brushstroke by brushstroke, the painter juxtaposes dots of pigment to create a sense of dynamism within this composition. Puffy clouds drift across a changeable sky, their undulating forms reflected in the water below. Signac used unmixed primary colors directly from his palette and applied them individually to the canvas, creating the illusion of blended tonalities. This work is an example of the divisionist technique. The brushstrokes are enlarged to form little blocks of color, similar to those employed by the fauvists. In 1913, Signac and his partner Jeanne Selmersheim-Desgrange—also a neo-impressionist painter—moved to Antibes. Although Signac was an experienced sailor, his scenes are almost always viewed from the shore. He made sketches and studies outdoors, and then created his finished works in his studio.

His Life (1863–1935)

Paul Signac was a painter, engraver, and theorist from a prosperous Parisian family. He began studying architecture, but later shifted to painting. In 1884, he met Georges Seurat at the Salon des Indépendants. Impressed by Seurat's technique, Signac joined the divisionist movement. He became one of its foremost proponents, abandoning the impressionist brushstroke technique. His subjects were primarily river landscapes and seaside ports of call for his sailboat. He became president of the Société des Artistes Indépendants in 1908 and was the first collector to purchase a painting by Henri Matisse. As an artistic patron, Signac supported young artists and exhibited fauvist and cubist works. After Seurat's death, the neo-impressionists regarded Signac as their spokesman. His writings, including *From Eugène Delacroix to Neo-Impressionism*, were highly influential and won international acclaim.

*An artist in search
of new landscapes*

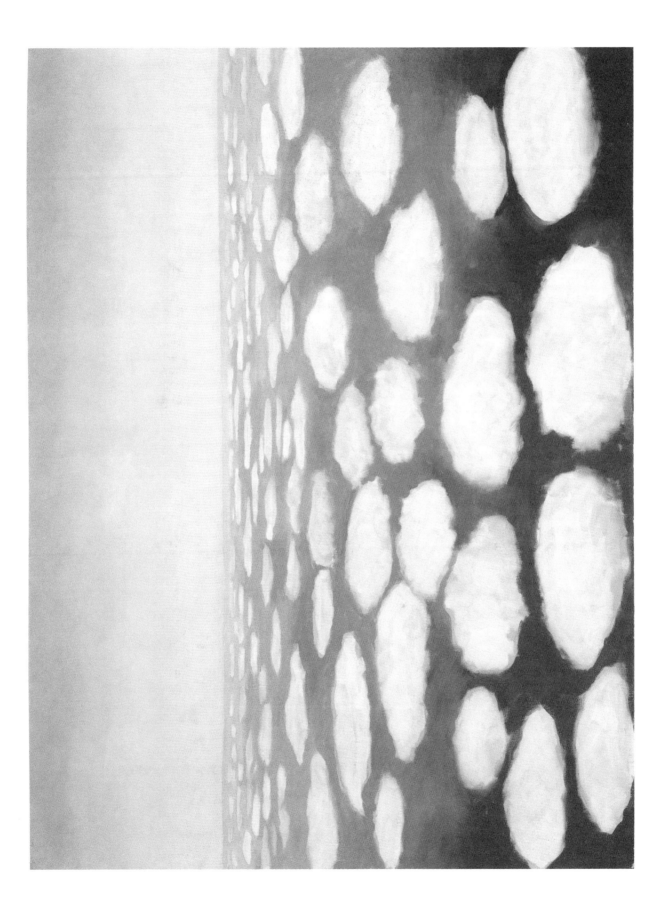

1962

Georgia O'Keeffe

Above the Clouds I
Oil on canvas
3 ft. ¼ in. × 4 ft. ¼ in.
(91.8 × 122.5 cm)
Georgia O'Keeffe Museum,
Santa Fe

Where to See Her Works

Brooklyn Museum, New York
Centre Pompidou, Paris
High Museum of Art, Atlanta
The Metropolitan Museum of Art, New York
Museum of Modern Art, New York
San Francisco Museum of Modern Art,
San Francisco
Whitney Museum of American Art, New York

The Work

The viewer soars at a lofty altitude, far above the earth and clouds that form a layer in the sky visible from the upper air. Receding into the distance, they gradually disappear into infinite space. The cottony forms could easily be mistaken for ice floes adrift on a frozen sea. Fascinated by the vistas of earth and clouds revealed from an airplane, Georgia O'Keeffe created a series of paintings in 1963. This work is one of the earliest canvases, and its relatively realistic approach later evolved toward more minimalist renderings. These expansive views were executed on a grand scale, enhancing a sense of vastness appropriate to the subject. This format was not without its drawbacks, however. *Sky Above Clouds IV* (1965) was never exhibited at the San Francisco Museum of Modern Art, because the canvas would not fit through any of the museum's doorways. With this celestial mural painting, O'Keeffe marks her own place—between abstraction and representation—in the history of painting.

Her Life (1887–1986)

Georgia O'Keeffe, an oil painter and watercolorist, was born in Sun Prairie, Wisconsin. She studied at the Art Institute of Chicago and the Art Students League of New York. Her early works were described as "organic abstraction," and were influenced by the French avant-garde and the compositions of Wassily Kandinsky. She was introduced to the photographer Alfred Stieglitz, who was impressed by her charcoal drawings and offered to exhibit them in his gallery. Their artistic collaboration inspired her approach to pictorial composition, which combined elements of abstraction and figuration. Well-known examples include a series of flower paintings in which the motif occupies the entire pictorial space, remote from any context. From 1925 until 1930, the two artists lived together in New York, where O'Keeffe painted cityscapes and skyscrapers. After several extended visits to New Mexico, and the death of Stieglitz in 1946, she settled there permanently in 1949. She concentrated on landscapes that evoke a sense of spiritual communion with the natural environment.

A pioneer of modern American art

2014

Hermione Carline

Blue Cloud
Oil on wood
15 ¾ × 19 ¾ in.
(40 × 50 cm)
Private collection

Where to See Her Works

Elena Shchukina Gallery, London

The Work

Honeycomb-like masses invade the picture plane, seeming to multiply before our eyes. The forms are proliferating. This impression is heightened by the effect of overlapping, which in turn creates additional colored forms. Immersing ourselves in this blue cloud with its innumerable elements, we realize that the canvas is merely a fragment or detail of something greater. Hermione Carline, who was trained as a textile designer, is intrigued by stenciled paintings. In this work, the artist explores the themes of light and shadow. She traveled around Japan between 2013 and 2016, and was struck by the interplay of light effects created in traditional Japanese homes by the combination of direct illumination and the light filtered through *shōjis* (sliding doors made from wooden frames covered with paper). Her application of several layers of opaque and translucent color evokes the transitory nature of light. The handcut paper stencils create a rhythmic harmony between the colors and blank areas of this abstract composition.

Her Life

Born into a family of artists living in Hampstead, Hermione Carline is an artist and teacher. She studied painting at the Camberwell School of Art and completed a master's degree in textile design at the Royal College of Art. Drawing inspiration from her travels, she paints canvases based on preparatory works that include drawings, stencils, and engravings. Carline works with color and fabric, seeking to recover the emotions inherent in her memories. Her process of continuous revision (superimposing layers, obscuring colors, and varying her choice of support) produces abstract, immersive works that are open to fresh interpretations and meanings.

Immersive, atmospheric painting

1953

Nicolas de Staël

Sea and Clouds
Oil on canvas
3 ft. 3 ½ in. × 2 ft. 4 ¾ in.
(100 × 73 cm)
Private collection

Where to See His Works

Milwaukee Art Museum, Milwaukee
Musée d'Art Moderne, Troyes
Musée des Beaux-Arts, Rennes
Musée Granet, Aix-en-Provence
Musée Picasso, Antibes

The Work

Clouds gently touched with hints of blue and white glide past, floating across a clear sky. Like Gustave Courbet, de Staël structured forms using a palette knife and spatula. Spread across the canvas, the thickness of the paint differentiates the compositional elements. As in seventeenth-century Dutch landscape paintings, the sky occupies almost the entire canvas, while the sea is reduced to a narrow strip below. This seascape is one of a series of forty works inspired by the artist's visit to Normandy. He worked in Honfleur, along the coast from Villerville to Dieppe, and in Varengeville, where the painter Georges Braque lived; he was a close friend and a frequent visitor. De Staël commingled a distinctive blend of abstraction and representation as his work continued to evolve throughout his lifetime.

His Life (1914–1955)

Nicolas de Staël was a French painter originally born in Russia. He studied at the Académie des Beaux-Arts de Saint-Gilles and at the Académie Royale des Beaux-Arts in Brussels from 1932 until 1936. De Staël particularly admired the French painters Cézanne and Matisse. In 1943, the artist executed his first abstract compositions featuring simplified geometric structures. "I don't believe there's a conflict between abstract and figurative painting. A painting should be both abstract and figurative. Abstract like a wall, figurative like the representation of a space." His paintings were exhibited in England, Paris, and New York, and his work received international recognition. Throughout his fifteen-year career, the artist continually challenged himself and refined his technique.

Subtle distinctions between surface and space

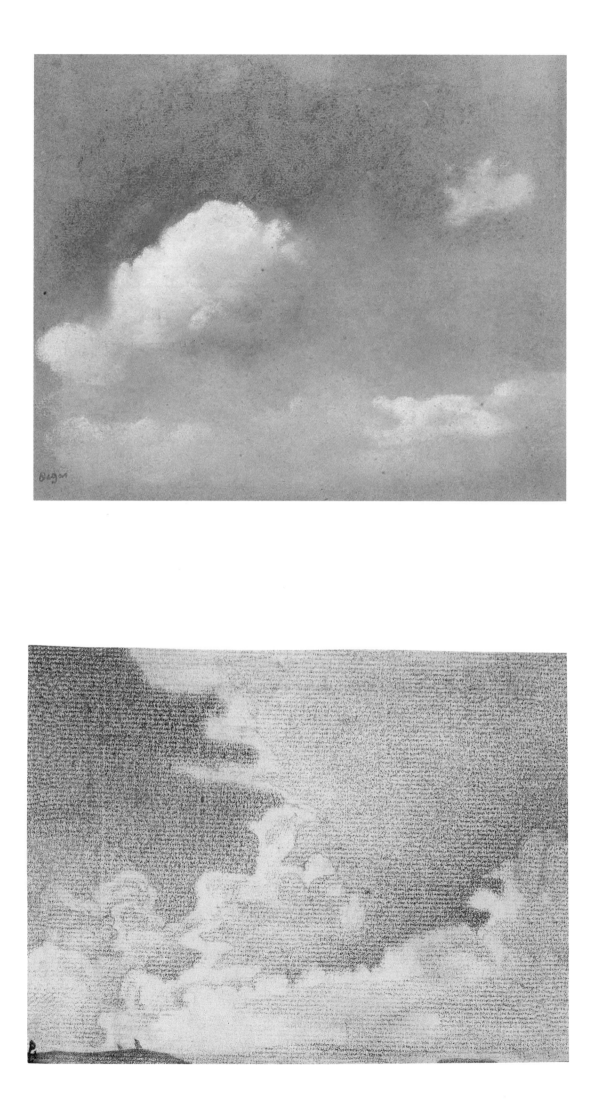

1869

Edgar Degas
Study of Clouds
Pastel
11 ½ × 14 ¼ in.
(29.2 × 36.2 cm)
Private collection

© Courtesy of Sotheby's Inc, 2002

Where to See His Works

Guggenheim Museum, New York
The Metropolitan Museum of Art, New York
Musée d'Art Moderne, Troyes
Musée d'Orsay, Paris
Musée des Beaux-Arts, Lyon
Musée des Beaux-Arts, Pau
Phillips Collection, Washington, D.C.

"Draw lines, many lines, from memory or from nature, and you will become a good artist." This was the advice given to Degas by Jean-Auguste-Dominique Ingres. The younger painter followed it to the letter, creating countless highly detailed preparatory drawings. All that remained was the touch of the painter's brush for them to become finished canvases. This study demonstrates Degas's attention to both drawing and color. He frequently used pastel, a medium that allowed him to seize transitory moments and easily alter forms and colors. In this work, the artist creates the impression of movement by blurring the outlines of the clouds and dimming the sky with muted shades of blue. The pastel is framed by a border of unfinished paper, and the effects of the material and light give an almost velvety quality to the composition.

Edgar Degas (1834–1917) was a French painter, sculptor, engraver, and photographer trained at the École des Beaux-Arts in Paris. He was inspired by the great Italian masters and his contemporaries Delacroix and Ingres. He organized the first impressionist exhibition in collaboration with Monet, Renoir, and Cézanne in 1874. There, he exhibited his pictures of dancers and ballerinas depicted in famously unconventional poses. Degas's style gradually evolved. Unlike most of the impressionists, he focused on interior scenes. The natural world interested him less than the realms of theatrical and musical performance.

1917–19

Nicholas Roerich
Sketch of Landscape and Clouds
Pencil on paper
4 ¾ × 5 ½ in.
(12 × 16.2 cm)
Private collection

© Christie's Images / Bridgeman Images

Where to See His Works

Nicholas Roerich Museum, New York
State Russian Museum, Saint Petersburg
Tretyakov Gallery, Moscow

In this small work, pencil strokes cover the paper support with shades of gray. Scattered clouds trace their patterns in a stormy sky. The horizon line, represented by a succession of low hills, is the composition's organizing element. A few pencil strokes suffice for the viewer to identify the work's subject. Roerich made use of the texture of the paper fibers in this landscape and cloud study, demonstrating his artistic sensibility as well as his mastery of drawing techniques. The use of subtle contrasts anticipates the painter's style in the later stages of his career.

Nicholas Roerich (1874–1947) was a Russian decorative painter born in Saint Petersburg. He began to study law in 1883 and enrolled in the Imperial Academy. From 1906 until 1918, Roerich served as director of the Imperial Society's School for the Encouragement of the Arts. He designed scenery and costumes for Diaghilev's Russian ballets and operas. Between 1925 and 1928, the artist and his wife embarked upon a trek across the Gobi Desert. When they returned, they established a center for Himalayan research. Roerich began to create numerous colorful paintings in 1927 during his travels in Asia. He died while exploring India's Kullu Valley.

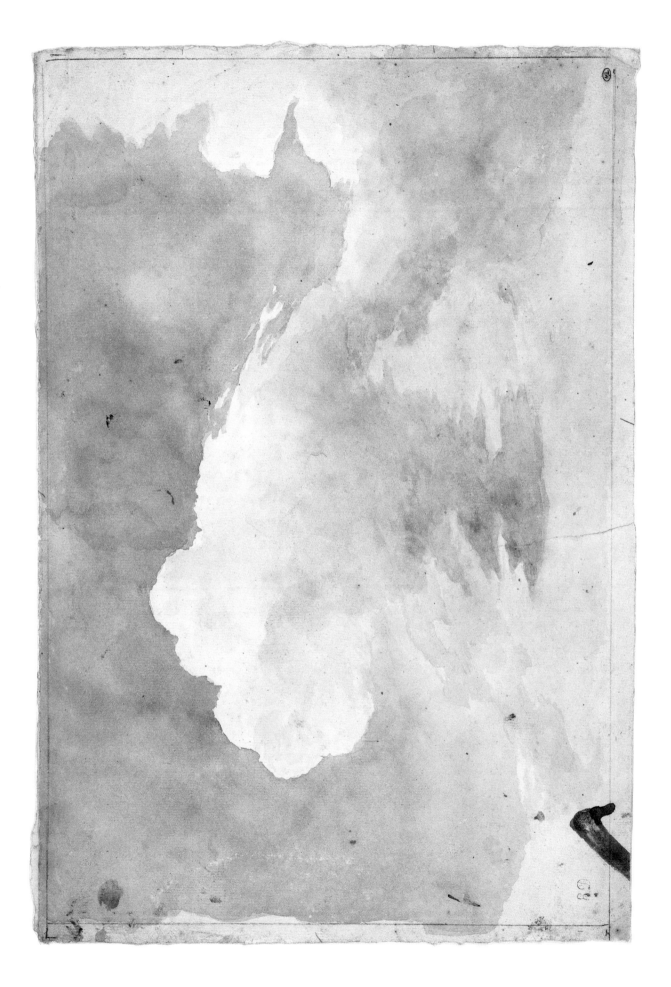

1824–26

Eugène Delacroix

Clouds in the Sky
Watercolor
10 ¾ × 15 ¾ in.
(27.2 × 39.8 cm)
Musée du Louvre, Paris

Where to See His Works

Art Institute of Chicago, Chicago
The Metropolitan Museum of Art, New York
Musée Bonnat-Helleu, Bayonne
Musée des Beaux-Arts, Bordeaux
Musée Fabre, Montpellier
Museum of Fine Arts, Houston

The Work

Blue ink spreads fluidly across the drawing's surface, and the viewer can follow its flow as it is absorbed by the paper. In the center and right side of the composition, the sky defines the contours of a cloud. The painter uses the color of the paper support as a base for adding darker shadows that hint at a threatening aspect of this looming cumulus cloud. The artist's brushstroke is visible in the lower left corner. It commands our attention, rousing us from contemplation and bringing us back to awareness of the technique and circumstances behind this drawing. Working "en plein air" or "sur le motif" (painting from nature) was widespread in the early nineteenth century. The practice was facilitated by the availability of easily transportable boxes of watercolors. Delacroix and Géricault both worked outdoors, inspiring the impressionist painters a few years later.

His Life (1798–1863)

Eugène Delacroix was a French painter, illustrator, and lithographer born in Charrenton-Saint-Maurice. Introduced to the arts in his childhood, he joined the studio of Pierre-Narcisse Guérin in 1815, where he met the influential artist Théodore Géricault. Delacroix created a sensation at the 1822 Salon with *The Barque of Dante* or *Dante and Virgil in Hell*. Considered the leader of the romantic movement, he startled audiences with his choice of subject matter and the intensity of his colors, in defiance of the era's established artistic conventions. Delacroix's scandalous reputation was unintentional: he did not set out to be a contrarian figure. A journey to north Africa in 1832 gave him a fresh source of inspiration. The drawings and notes organized in his travel diaries were the basis for paintings with an intimist atmosphere and intense colors, which he later executed in his studio. Delacroix was a major figure in the history of painting and left an impressive body of work: some 1,500 paintings and thousands of drawings. His *Journal*, with notes made between 1822 and 1824 and from 1847 until 1863, recorded his theories and observations, providing valuable insights into his personal reflections and the thoughts of his contemporaries.

A matchless colorist

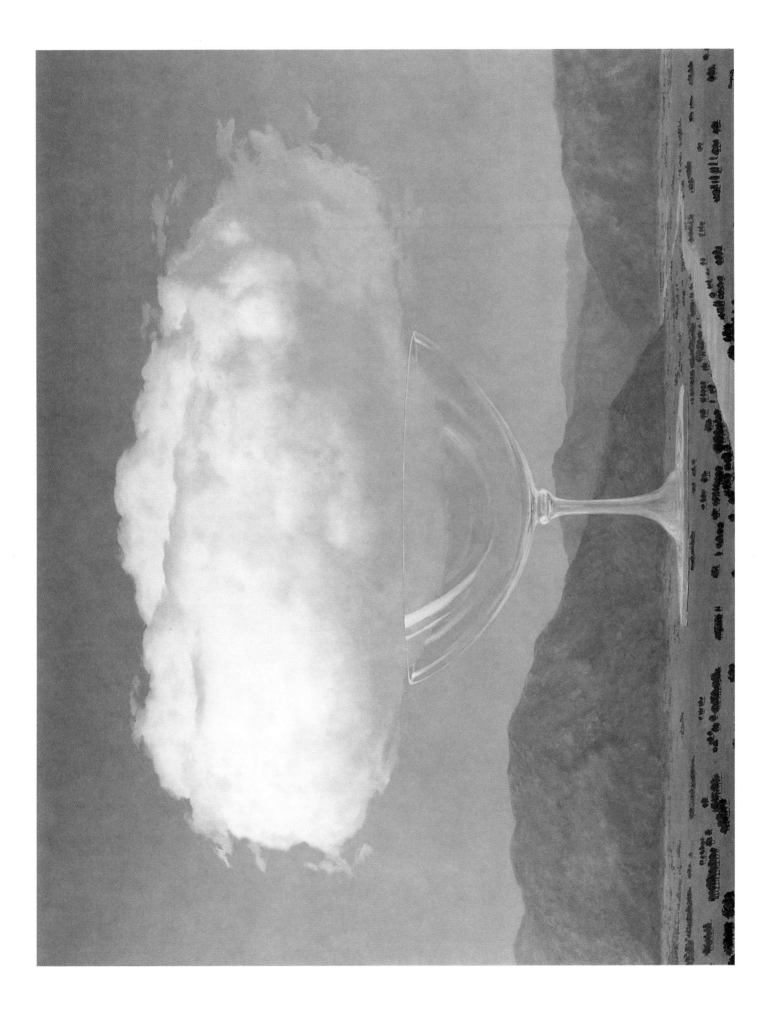

1960

René Magritte

The Heartstrings
Oil on canvas
3 ft. 9 in. × 4 ft. 9 ½ in.
(1.14 × 1.46 m)
Private collection

Where to See His Works

Art Institute of Chicago, Chicago
Centre Pompidou, Paris
Guggenheim Museum, New York
Los Angeles County Museum
of Art, Los Angeles
The Metropolitan Museum of Art, New York
Musée de Grenoble, Grenoble
Musées Royaux des Beaux-Arts
de Belgique, Brussels
Museum of Modern Art, New York
Philadelphia Museum of Art, Philadelphia

The Work

What are we to make of the incongruous scale of a crystal goblet standing on an empty plain rimmed by mountains? The cloud within it is even more imposing. Fluffy and luxuriant, it overflows the empty glass. The strange disproportion among the painting's components defies any rational understanding. Disoriented and searching for an explanation, the viewer might turn to the work's title, although Magritte never named his paintings to clarify their meanings. Of course the expression "tugging at the heartstrings" comes to mind. Was Magritte trying to create a sense of unease in the viewer, or is that an unwarranted speculation? His work often features images whose highly accurate representations defy interpretation. Although these elements are commonplace objects, they provoke bewilderment and perplexity when they are juxtaposed on a canvas. Their incongruous propositions jar our assumptions. As realistic as these representations may be, the artist always insists that the image of an object is not to be confused with the object itself.

His Life (1898–1967)

René Magritte, born in Lessines, Belgium, began his career as a commercial artist and designer in a wallpaper factory. He was fascinated by the sense of mystery that emanated from Giorgio de Chirico's metaphysical paintings; Magritte's first surrealist work, *The Lost Jockey*, was strongly influenced by de Chirico. Magritte and his wife Georgette Berger moved to France, where they were welcomed into Parisian surrealist circles and met André Breton. But artistic differences within the group and the economic difficulties of the 1930s soon led Magritte to return to live in Belgium permanently, where he renewed his contacts with the surrealist painters he had worked with earlier. Magritte's works are distinguished by the relationships they suggest between words and images. The ironic wit and strangeness of these paintings arise from the disparity between objects and their representations. Magritte's work features recurring motifs and reveals the influence of the striking compositions that are typical of posters and advertisements.

*Painting
a disorienting reality*

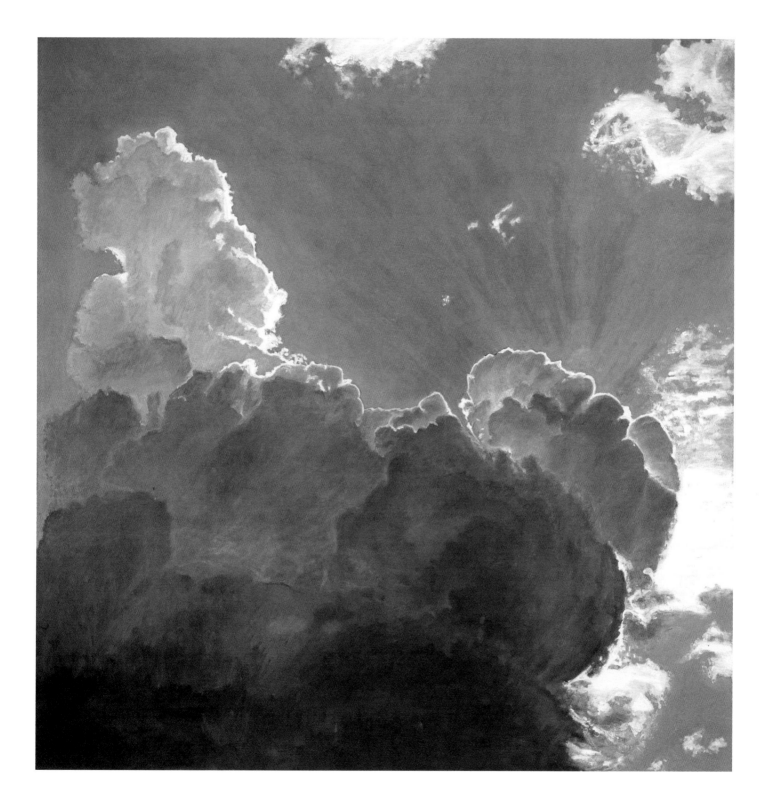

2012

Helen White

Relentless Light
Oil on canvas
3 ft. 11 ¼ in. × 3 ft. 11 ¼ in.
(1.20 × 1.20 m)
Private collection

The Work

Purplish and menacing, a cloud—seemingly on the point of exploding into a torrent of rain—looms heavily within a clear sky. The composition comes alive as sunlight pierces the threatening mass with brilliant rays, producing silvery contrasts and further enhancing the work's realism. The artist uses photography as an important aspect of her creative process. Photography was the initial step in creating this canvas: once the image of the actual scene was captured by the camera, the artist reworked it in paint. Her use of saturated color further enhances her almost mystical vision of the sky.

Her Life

Helen White is a self-taught painter, photographer, and designer born in the United Kingdom. She lives and works in Berkshire. Following a lengthy illness, the artist resumed painting in 2006. She is dedicated to her work, and her artistic endeavors have become an important aspect of her healing process. An intuitive painter, she devotes herself to subjects that are suffused with light, the dominant subject of her art.

*Works that
let the light in*

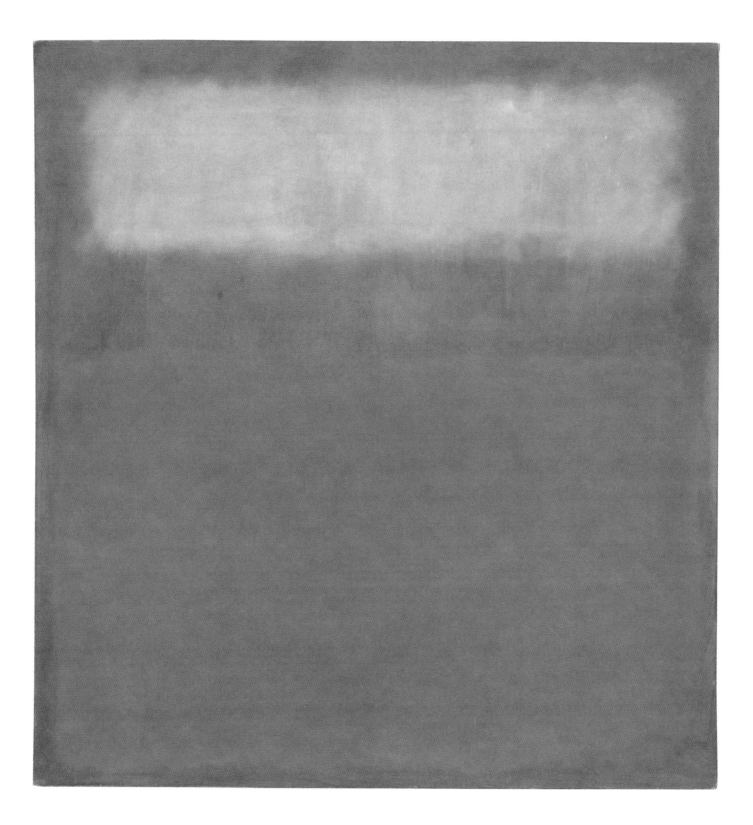

1956

Mark Rothko

White Cloud
Oil on canvas
5 ft. 6 ½ in. × 5 ft. 2 ¾ in.
(1.68 × 1.59 m)
Private collection

Where to See His Works

Centre Pompidou, Paris
The Metropolitan Museum of Art, New York
Museum of Modern Art, New York
Rothko Chapel, Houston
Tate Modern, London;
Tate Liverpool; Tate St Ives
Whitney Museum of American Art, New York

The Work

This work requires no iconographic decoding. Its sensibility and intelligibility speak for themselves. We are instantly transfixed by the painting's chromatic effects, finding ourselves transported into a spiritual realm. As Rothko stated in "A Symposium on How to Combine Architecture, Painting, and Sculpture" (May 1951), "To paint a small picture is to place yourself outside your experience.... However you paint the larger picture, you are in it." Various rectangular shapes of different dimensions are defined by background colors with soft, almost velvety, textures. To achieve this effect, Rothko applied a layer of glue to the canvas, then laid down various colors over the surface. He combined pigments with turpentine (a solvent) so that the colors seem to float transparently on the canvas. They reveal how the artist's hand superimposed zones of color to create unique effects. Between 1950 and 1957, Rothko executed vast canvases of fluid, rectangular forms that embrace variations in color and light, intensifying the viewer's experience. Rothko refused to frame his works. He felt the practice would impede the viewer's freedom of interpretation. The artist also insisted on hanging his canvases at eye level to enhance the immersive experience.

His Life (1903–1970)

Marcus Rothkowitz, known as Mark Rothko, was a Russian painter born in Latvia. He emigrated to the United States at the age of ten. In 1923, Rothko abandoned his literary studies at Yale to pursue his artistic training in New York. Influenced by Max Weber, he began painting figurative expressionist works. In 1935, he founded the artistic protest group known as "The Ten" with Adolph Gottlieb. It was a movement that investigated the potentials of surrealist automatism, a colorful and increasingly abstract form of painting. The discovery of Matisse's 1908 *The Red Room* was a revelation for Rothko. Following the war, he painted large-scale abstract expressionist works, adopting vertical formats whose fluid contours and glowing colors drew viewers into a kind of mystical communion with the work. In reaction to the action painting movement of the 1940s and 1950s, Rothko embraced color field painting, a school that included the work of Clyfford Still, Helen Frankenthaler, and Barnett Newman. Rothko was an independent spirit who refused to be associated with any single school, believing such limitations would be "alienating."

*Colorful canvases
that embrace spirituality*

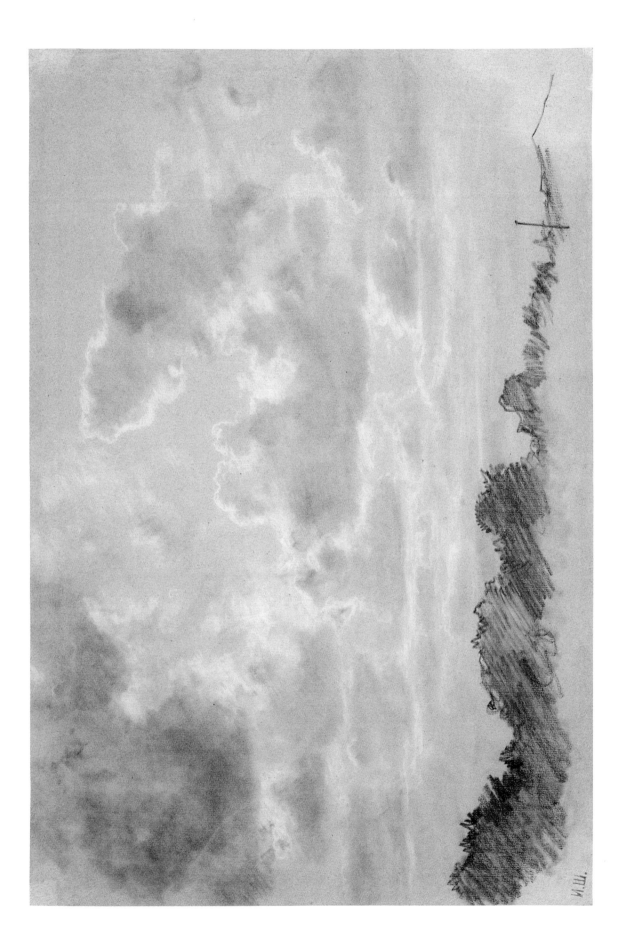

1880

Ivan Ivanovitch Shishkin

Clouds (study)
Chalk and charcoal on paper
12 ½ × 18 ½ in.
(31.6 × 46.8 cm)
State Tretyakov Gallery,
Moscow

Where to See His Works

Kiev National Museum of Russian Art, Kiev
The State Russian Museum, Saint Petersburg
Yaroslavl Art Museum, Yaroslavl

The Work

Exuberant shrubbery, simply sketched with pencil strokes, serves as the base of the much more detailed drawing in the composition's upper register. The meticulously detailed clouds, executed in chalk and charcoal, are at one with the paper support. The paper's distinctive qualities are significant because it has its own role to play in the work's gray scale. Blurring some lines and emphasizing others, Shishkin thus nuances the effects he wants to obtain. The artist spent his childhood in the Ural woodlands along the Volga and remained attached to these landscapes throughout his lifetime. He spent countless hours drawing outdoors, depicting nature with the utmost attention to minute details. Returning to his studio, he used these sketches and studies as the basis for incredibly realistic canvases on a monumental scale.

His Life (1832–1898)

Ivan Ivanovitch Shishkin, a Russian painter, engraver, and teacher, was born in Yelabuga. He studied in Moscow's School of Painting, Sculpture, and Architecture, and continued his training at the Imperial Academy of Arts in Saint Petersburg from 1856 until 1860. He went on to become a professor there. He left Russia to complete his training in the Düsseldorf Academy. Shishkin was a skilled landscape painter, and his work is distinguished by its realism and technical mastery. An artist with a strong scientific bent, he researched his subjects extensively. In 1870, he joined the Wanderers (or Itinerants) artistic movement, the first association of Russian painters, which was established in reaction to the Academy's teaching practices. He founded the Russian Watercolorists' Society the following year. Shishkin exhibited his work in various locations abroad, including at several World's Fairs, until 1873.

*A prodigy
of realism*

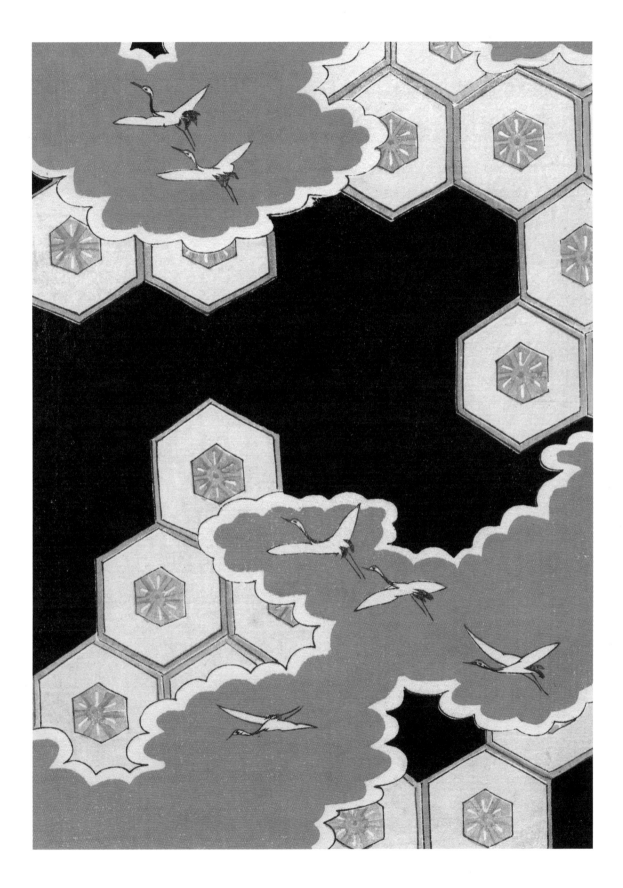

1902

Japanese school

Red Clouds with Flying Cranes
Engraving on wood, color print
in *Shin-Bijutsukai*,
"the new monthly magazine
of various designs by the
famous artists of today"
9 ½ × 6 ½ in.
(24.1 × 16.5 cm)
Smithsonian Institution,
Washington, D.C.

The Work

Geometric figures on the paper's surface intersect with cloudlike forms that encompass flying cranes. Black ink anchors the background of the engraving, creating a powerful contrast that enhances the other elements of the design. Symbolizing good fortune and long life, these magnificent birds frequently appear in works that are inspired by a Japanese aesthetic, particularly textiles. *Shin-Bijutsukai* was a Japanese design magazine published in Kyoto by the illustrator and designer Korin Furuya. It appeared monthly between 1901 and 1902, presenting illustrations "by the famous artists of today." This work was given to the Smithsonian Institution by the American artist Robert Winthrop Chanler.

The Context

These original works were published for an audience of artists and artisans, offering them fresh design concepts and providing inspiration. Many examples were published in response to growing international export demand during the Meiji Period (1868–1912). As the vogue for Japonism grew in the 1860s, Japanese artists and artisans were increasingly sought after, particularly in Europe. These popular prints featured subtle colors and fine papers, and were easy to package and distribute. Design competitions were organized to encourage young artists. Winning works were published, contributing to the development of the profession of the artist designer.

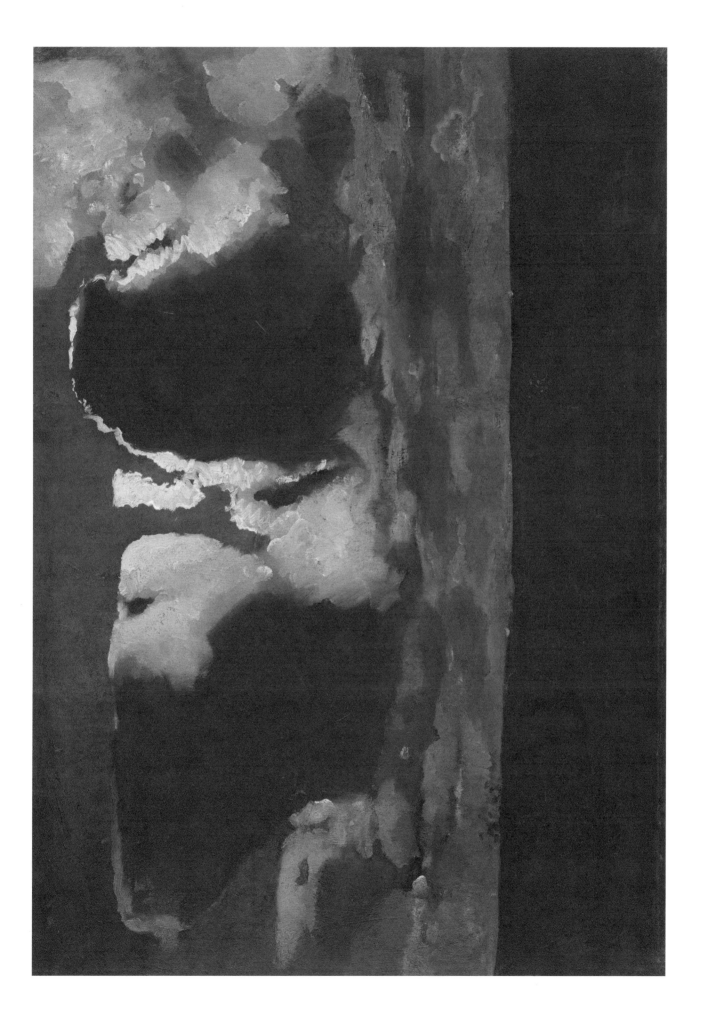

1887–89

George Hendrik Breitner

Moonlight
Oil on canvas
3 ft. 3 ¾ in. × 2 ft. 4 in.
(101 × 71 cm)
Musée d'Orsay, Paris

Where to See His Works

Gemeentemuseum Den Haag, The Hague
Groninger Museum, Groningen
Rijksmuseum, Amsterdam

The Work

Floating in the night sky, the moon illuminates two vast clouds from behind. They appear as geometric masses highlighted with touches of white and shades of gray, seeming to levitate as they drift across the clear sky. The sky dominates a composition that rests upon a dark horizontal band. Two touches of orange glow in the distance, adding a sense of depth to the landscape. The artist suggests trees in the foreground with a few brushstrokes, again adding a sense of perspective to the composition. The originality of this work exerts a potent fascination, and it has challenged major twentieth-century artists, as well as some of our contemporaries. These include the French painter Christian Jaccard, who perceived an affinity with the phenomena of "ignition," one of the techniques he employs in his work.

His Life (1857–1923)

George Hendrik Breitner, a Dutch painter and photographer, was born in Rotterdam. He received his artistic training at the Royal Academy of Art in The Hague, in the studio of Willem Maris, a prominent figure in the naturalist movement.
In 1886, Breitner moved to Amsterdam, where urban life inspired his paintings, drawings, and photographs. Between 1893 and 1896, he executed fourteen canvases depicting the Dutch model Geesye Kwak in his *Series of Girls in Kimonos*, a significant landmark in Japonism. Breitner's work was inspired by the impressionist movement in Amsterdam, and it influenced Vincent van Gogh and Piet Mondrian.

*A work
of contrasts*

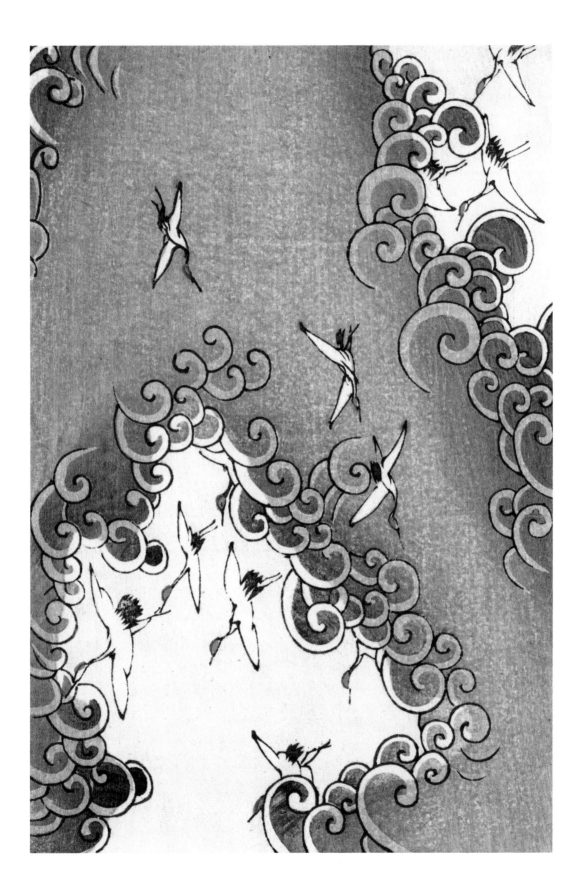

1902

Japanese school

Cranes Flying in Gray Clouds
Wood engraving, color print
in *Shin-Bijutsukai,*
"the new monthly magazine
of various designs by the
famous artists of today"
4 ¾ × 3 ¼ in.
(12 × 8.2 cm)
Smithsonian Institution,
Washington, D.C.

The Work

Elegant red-crested cranes migrate toward Siberia, winging their way through clouds and stylized volutes. The scarlet details brilliantly set off the work's monochromatic color scheme, and the meticulous drawing technique and contrasts enhance the impact of the color. *Shin-Bijutsukai* was a Japanese design magazine published in Kyoto by the illustrator and designer Korin Furuya. It appeared monthly between 1901 and 1902, presenting illustrations "by the famous artists of today." This work was given to the Smithsonian Institution by the American artist Robert Winthrop Chanler.

The Context

These original works were published for an audience of artists and artisans, offering them fresh design concepts and providing inspiration. Many examples were published in response to growing international export demand during the Meiji Period (1868–1912). As the vogue for Japonism grew in the 1860s, Japanese artists and artisans were increasingly sought after, particularly in Europe. These popular prints featured subtle colors and fine papers, and were easy to package and distribute. Design competitions were organized to encourage young artists. Winning works were published, contributing to the development of the profession of the artist designer.

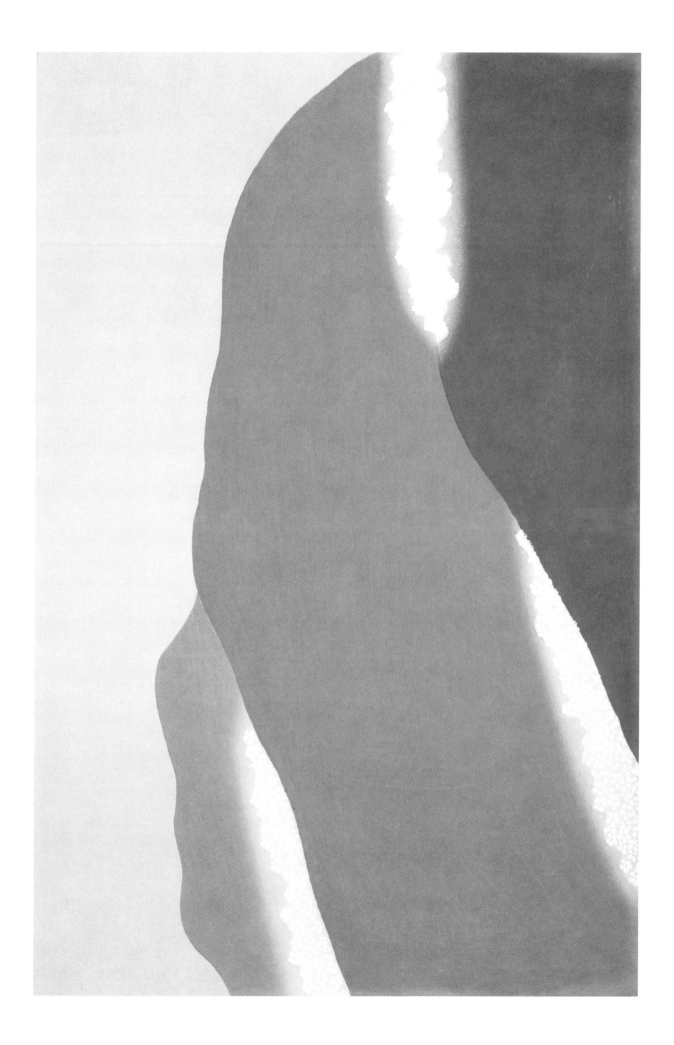

1910

Kamisaka Sekka

Landscape View of Yoshino
Color woodcut
11 ¾ × 17 ⅝ in.
(30 × 44.8 cm)
Private collection

Where to See His Works

Art Institute of Chicago, Chicago
Birmingham Museum of Art, Birmingham, AL
The Clark Art Institute, Williamstown, MA
Los Angeles County Museum
of Art, Los Angeles
The Metropolitan Museum of Art, New York

The Work

This view of Yoshino on Japan's Kii Peninsula depicts its sacred mountains. The pastel colors lend a peaceful quality to the composition. On either side of the austere slopes, small jewel-like shapes cluster like tiny clouds. Their sparkling presence enlivens the composition, adding a hint of the supernatural to the simplified forms of this landscape. Perhaps they are meticulous renderings of the delicate white flowers that flourish in this region with the coming of springtime. Kamisaka Sekka was an exponent of the Rinpa movement. This school was known for its use of brilliant color and bold compositions as modern artists revived the aesthetic sensibility of the seventeenth century.

His Life (1866–1942)

Kamisaka Sekka was a painter, designer, and engraver, born in Kyoto to a samurai family. He was active during the Meiji era and the first half of the Shōwa period. Sekka is considered to be the last representative of the Rinpa school. These artists drew inspiration from nature and frequently used brilliantly colored plant, bird, and flower motifs on backgrounds of gold or silver leaf. In 1910, Sekka visited Glasgow, where he was impressed by the art nouveau style developing there. He began to include Western techniques in his work. His style evolved to feature large zones of solid color, free of embellishment, recalling the work of the Nabis. Sekka visited Europe on several occasions, participating in the World's Fairs, where he won a gold medal in 1900.

*The fusion of decoration
and representation*

Text by
Pascaline Boucharinc

Design
Roman Rolo

French Edition

Editorial Director
Julie Rouart

Administration Manager
Delphine Montagne

Editor
Mélanie Puchault

English Edition

Editorial Director
Kate Mascaro

Editor
Helen Adedotun

Translated from the French by
Elizabeth Heard

Copyediting
Penelope Isaac

Typesetting
Claude-Olivier Four

Proofreading
Nicole Foster

Production
Corinne Trovarelli

Color Separation
Les Artisans du Regard, Paris

Printed in Belgium by Graphius

Front cover: © Shutterstock / Photographee.eu
Originally published in French as *Dans les nuages*
© Flammarion, S.A., Paris, 2019

English-language edition
© Flammarion, S.A., Paris, 2020

87, quai Panhard et Levassor
75647 Paris Cedex 13

editions.flammarion.com

20 21 22 3 2 1

Distributed by Rizzoli/Penguin Random House:
978-2-08-020440-0

Distributed by Thames & Hudson and Flammarion:
978-2-08-020450-9

Legal Deposit: 03/2020

Creating Your Home Gallery

These prints can be framed effortlessly; they fit standard 9 × 12 in. or 24 × 30 cm frames (6 × 8 in. or 15 × 20 cm frames for the half-page prints). They also look attractive pinned to the wall with decorative thumb tacks.

For an attractive display, the works should ideally be placed 1¼ to 2 in. (3 to 5 cm) apart. Ensure the frames are equally spaced.

Alternate between portrait (vertical) and landscape (horizontal) formats for variety and harmony.

Align certain frames so as to create visual lines and add structure to the overall display.

Try distancing similar designs from each other to create additional visual interest.

The secret to creating a successful display is to establish interactions between key elements formed by colors or contours. A horizontal line will be the perfect counterpoint to a vertical motif, for example.

Changing the display regularly will instantly update your decor.